NORMAN LUNDIN: A DECADE OF DRAWING AND PAINTING

NORMAN LUNDIN: A DECADE OF DRAWING AND PAINTING

Introduction by Robert Flynn Johnson

An Interview with the Artist by Patricia Failing

LONG BEACH MUSEUM OF ART

in association with

TAI ASSOCIATES INTERNATIONAL INC.

DISTRIBUTED BY THE UNIVERSITY OF WASHINGTON PRESS

SEATTLE & LONDON

This catalogue has been published in conjunction with the traveling exhibition,
NORMAN LUNDIN: A DECADE OF DRAWING AND PAINTING
organized by the Long Beach Museum of Art, California
in association with Tai Associates International Inc., New York.

The exhibition and catalogue would not have been possible without the support and
cooperation of Adams-Middleton Gallery, Dallas; Olga Dollar Gallery, San Francisco;
Francine Seders Gallery, Seattle; Space Gallery, Los Angeles and especially Stephen Haller Fine Art, New York.

EXHIBITION TOUR
August 1990–December 1991

LONG BEACH MUSEUM OF ART
Long Beach, California

ARKANSAS ARTS CENTER
Little Rock, Arkansas

HUNTSVILLE MUSEUM OF ART
Huntsville, Alabama

BERGEN MUSEUM OF ART AND SCIENCE
Paramus, New Jersey

BOISE ART MUSEUM
Boise, Idaho

NEWCOMB ART CENTER, TULANE UNIVERSITY
New Orleans, Louisiana

Exhibition Curator: Josine Ianco-Starrels
Exhibition and Tour Coordinators: Jane S. Tai and Jeffery J. Pavelka

ISBN 0-295-97049-9
See page 64 for CIP.

Catalogue Design: Katy Homans
Printed by South China Printing Co. Ltd.
Typeset by Trufont Typographers
Front Cover: Plate 22
Back Cover: Plate 1

Printed in Hong Kong

CONTENTS

LIST OF LENDERS

Achenbach Foundation for Graphic Arts
The Fine Arts Museums of San Francisco

Adams-Middleton Gallery

Ardys and Robert Allport

Carlin Axelrod

Patricia and Andrew Bauman

Rundy Bradley

Jane M. and David R. Davis

Olga Dollar Gallery

The Goldberg Foundation

Stephen Haller Fine Art

Huntsville Museum of Art

Jil and Mark Kreher

Norman Lundin

Cliff Michel

Sidney and George Perutz

Riddell, Williams, Bullitt & Walkinshaw

Charles Rynd

Gary and Kathleen Schneiderman

Seattle City Light Portable Works Collection

Francine Seders Gallery

Mike and Janet Slosberg

Space Gallery

ACKNOWLEDGMENTS

JOSINE IANCO-STARRELS

For longer than a decade I have followed Norman Lundin's exhibitions with great interest. To my mind his work has a unique quality and his impressive technical achievements allow him to articulate his ideas into persuasive images. In an increasingly anxious and troubled world there are but few artists left whose spirit conveys the yearning for a refuge from daily struggles and whose vision yields images which so soothe the soul.

I have always found comfort in Lundin's art, in the implied silence of his rooms with their ascetic simplicity, and in the subtle way in which the cool sunlight of the Pacific Northwest streams through the windows, barely able to warm those minimal interiors. The human presence, or the lack of it, hardly seems to matter. Lundin's evocative powers are revealed as he conveys his experience, rather than replicating reality, in images of quiet contemplative moments spent outside the boundaries of assigned time and oppressive deadlines.

It is the artist's vision which made a group of art professionals—many of whom did not know each other—join forces to work on this project. It gives me great pleasure to acknowledge the following people whose contributions to this exhibition and catalogue have been invaluable.

First and foremost I would like to express my gratitude to the artist, Norman Lundin, whose work inspired us and provided the impetus for all our efforts. I would like to thank Robert Flynn Johnson, Curator in Charge, the Achenbach Foundation for Graphic Arts, The Fine Arts Museums of San Francisco, for his illuminating essay. Thanks are also due to Patricia Failing, Assistant Professor of Art History at the University of Washington, Seattle for her interview with Norman Lundin.

Special thanks are due Stephen Haller, who first suggested the idea of a traveling exhibition and caused us all to embark on this journey. We could not have organized the exhibition or published the catalogue without the support and continuing cooperation of Ardys Allport, Olga Dollar, Stephen Haller, Edward Lau, Anita Middleton and Francine Seders. Personal appreciation is due to Edward Lau, who brought the works of Norman Lundin to Los Angeles and thus enabled me to see them.

Heartfelt appreciation to Jane Tai of Tai Associates International Inc., New York and her colleague Jeffery J. Pavelka of 3E Inc., who through their unflagging efforts and thorough professionalism, changed an idea into reality.

I also wish to acknowledge the support of Harold B. Nelson, Director of the Long Beach Museum of Art, whose commitment to this project has brought it to fruition and to express my appreciation to the entire museum staff for their efforts and cooperation on behalf of the exhibition.

Sincere appreciation is also due to Alaska Airlines for partially underwriting the cost of the Long Beach presentation of the exhibition. Finally I take great pleasure in thanking the museums and private lenders who have generously parted with their works for this tour.

INTRODUCTION

ROBERT FLYNN JOHNSON

It is very good to copy what one sees; it is much better to draw what you can't see any more but in your memory. It is a transformation in which imagination and memory work together. You only reproduce what struck you, that is to say the necessary. That way, your memories and your fantasy are freed from the tyranny of nature. —Edgar Degas

The art of Norman Lundin seduces our eyes with the appearance of reality. His superior draughtsmanship creates the illusion of rendering, in observable fact. Yet, representation in Lundin's work is only the beginning, part of the journey but certainly not the destination. Lundin's art is of a world constructed through line, color, composition, and choice of subject matter. It is an art abundant with feeling to the viewer willing to traverse the visible into the subconscious. It is a world created through his memory that resonates in our own.

Norman Lundin was born in Los Angeles in 1938 although he grew up in Chicago. His first formal art training occurred at the School of the Art Institute of Chicago where he received his Bachelor's Degree. In the early 1960s, Lundin also intensified his relationship and knowledge of the art of the past by working as Assistant to the Director at the Cincinnati Art Museum. While there, one of his responsibilities was the reconstitution of two original twelfth-century Spanish Romanesque murals within an architectural setting. One was the tomb of Don Sancho Saiz Carillo and the other was the chapel of San Baudelio de Berlanga. This early involvement with architecture, while not apparent in his work of the time, was to become a dominant element in his art a decade later.

A recipient of numerous awards and grants throughout his career (including grants from the Louis Comfort Tiffany and Ford Foundations and the National Endowment for the Arts). Lundin made propitious use of a Fulbright scholarship in 1963–1964 studying abroad in the Scandinavia of his roots. Oslo, Norway was his destination and the work of the great Norwegian, Edvard Munch (1863–1944), was the focus of his study. Munch was then and, to a certain extent, still is the only Scandinavian painter of world-wide fame. While there, Lundin experienced the work of numerous other Northern artists for the first time. It was their depiction of light through the utilization of white paint that impressed Lundin. The major exhibition *Northern Light: Realism and Symbolism*

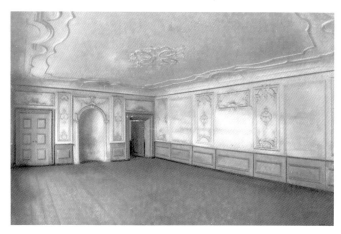

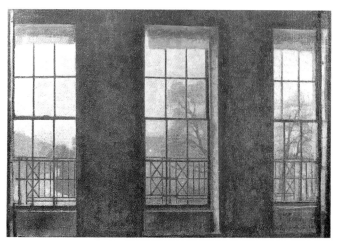

figure 1
Vilhelm HammersHøi (Danish, 1864–1916)
A rococo room in Lindegaarden at Kallenborg, 1909
oil on canvas, 24 × 45″
Bury Street Gallery, London

figure 2
Vilhelm HammersHøi (Danish, 1864–1916)
A view of Brunswick Square, London, 1913
oil on canvas, 21 × 30″
Bury Street Gallery, London

in Scandinavian Painting 1880–1910 which toured America in 1982–1983 was seen by many as a revelation but to Lundin it was simply a reacquaintance with old friends. Just as the reputation of Gustave Caillebotte (1848–1884) was significantly reevaluated as a result of his inclusion in the 1986 group exhibition *The New Painting: Impressionism 1874–1886*, so too was the stature of Vilhelm HammersHøi (1864–1916) by the exhibition *Northern Light*. HammersHøi was a master of mood through the depiction of light in compositions of the utmost simplicity. Whether portraying interior light in a strongly illusionistic composition (figure 1) or picturing exterior light from within (figure 2) his works have a commanding presence. They were, however, the type of contemplative art that Munch rebelled against when he wrote, "There should no longer be painted interiors, people reading and women knitting. There should be living people who breathe and feel, suffer and love."[2] Lundin took note of HammersHøi while in Scandinavia but that influence would not appear until almost a decade later.

Returning to America, Lundin's art of the 1960s emphasized a rigorous concern for fine draughtsmanship in an era of flaccid inattention to the craft of art. His work alternated between loosely sensual depictions of the female body and expressionistic renderings of extreme subject matter such as howling dogs and hanged men. They showed the residual influence of his interaction with Edvard Munch. America in the late 1960s was a society in turmoil and Lundin's art reflected that fact. Being

included in the seminal 1969 exhibition at the Whitney Museum of American Art *Human Concern/Personal Torment*, however, marked an end not a continuation of this phase of Lundin's development. A turning inward had begun.

The female figure standing, sitting, or reclining in sparse, light-filled surroundings became his prime focus in the early 1970s. Shunning the exaggerated cropping of Phillip Pearlstein and the theatrical lighting of Alfred Leslie, Lundin painted his nudes so that they equated to the neutral surroundings he placed them in. In fact, in several depictions of a figure lying supine on a tabletop, the impression is one of a cadaver rather than a nude. Subtlety of purpose through ambiguity of meaning was a growing focus of his art. As far back as 1973 Lundin expressed his ambivalence about the role of content in his work. He wrote, "As a painter, I find myself more interested in the formal problems of painting than I have been in the past. I am now interested in form, [as opposed to content], because, well, content seems to take care of itself."[3] Finally the inherently charged nature of placing a figure within a space was defused through the removing of the figure entirely from his compositions by the beginning of the 1980s.

Expression had led to figuration which in turn had evolved into a form of largely interior minimalism. Within these spaces the presence of man is felt but not man himself. Lundin is one of a distinguished group of twentieth-century artists whose art has encompassed the interior as a metaphor for the "quiet desperation" of living in the modern world.

Edwin Dickinson (1891–1978), a favorite artist of Lundin's, created dream-like visions out of straightforward domesticity (figure 3). In turn, Andrew Wyeth (b. 1917) especially in his earlier works was capable of paintings of quiet tension. *Ground Hog Day* (figure 4) is such a painting, full of detail yet equally ambiguous as to its true meaning. Wyeth spoke of this ambiguity, "I think a lot of people get to my work through the back door. They're attracted by the realism, then begin to feel the abstraction. They don't know why they like the picture. Maybe it will be the sunlight—like *Ground Hog Day*—hitting on the side of the window. They enjoy it because perhaps it reminds them of some afternoon. But to me the sunlight could just as well be moonlight as I've seen it in that room. Maybe it was Halloween—or a night of terrible tension, or I had a strange mood in that room. There's a lot of me in that sunlight an average person wouldn't see. But it's all there to be felt."[4]

Much of what Wyeth says could equally be addressed to Lundin's work of the 1980s. In Lundin's interiors, the first sensation is one of confident recognition followed by a vague unease as to the reason one has been artistically transported to such a place.

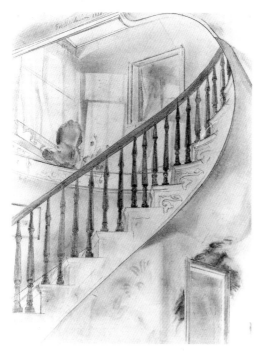

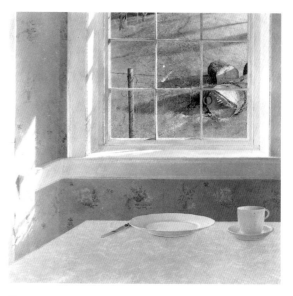

figure 3
Edwin Dickinson (American, 1891–1978)
Staircase, The Manse at Ulysses, 1928
pencil on paper, 10 × 7¾"
Collection of Mr. and Mrs. Robert C. Graham, Sr.

figure 4
Andrew Wyeth (American, b. 1917)
Ground Hog Day, 1959
tempera on panel, 31 × 31"
Philadelphia Museum of Art,
Given by Henry F. du Pont and Mrs. John Wintersteen, 59.102.1

Probably the finest twentieth-century painter of interiors, and the emotions they engender, was Edward Hopper (1882–1967). His scenes of commercial and domestic spaces (figure 5) have a veneer of normalcy, even boredom about them. It is however, through Hopper's use of light, both natural and artificial, that the extraordinary experience of feeling the passage of time within a static work of art takes place. The presence of time passing is also an underlying element of Lundin's interiors. The streak of sunlight on a wall is captured for a moment prior to its impending growth, lengthening, or disappearance. Scientists say that movement is the major characteristic of living things. It is Lundin's depiction of light and its implied movement within his art that energizes and gives life to his art.

Conveying a particular emotion in his interiors is not Lundin's purpose. Unlike Alice Neel (1900–1984), whose powerful 1970 painting *Loneliness* (figure 6) specified the emotion she wished to convey, Lundin plays a more subtle game upon our memory and feelings. A blackboard or fire extinguisher might bring back thoughts of school days. Folded up chairs against the wall might trigger a remembrance of boring meetings. His occasional use of glass jars and bottles upon tables suggests teaching activity although they are often placed incongruously upon a tablecloth with a bright orange border.

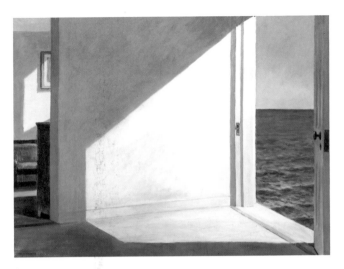

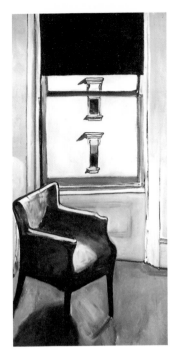

figure 5
Edward Hopper (American, 1882–1967)
Room by the Sea, 1951
oil on canvas, 29 × 40″
Yale University Art Gallery, New Haven
Bequest of Stephen Carlton Clark, B.A. 1903

figure 6
Alice Neel (American, 1900–1984)
Loneliness, 1970
oil on canvas, 80 × 38″
Collection of Arthur M. Bullowa
Courtesy of the Robert Miller Gallery, New York

In addition to his use of light, viewpoint is central to Lundin's art. There exists a complex choreography within his interiors which always suggests the world beyond the picture plane. It is a world of gray-brown institutionally bare normalcy that the artist has chosen for his art. From this inauspicious setting has come his restrained yet provacative commentary on contemporary life. Like Vermeer painting in a twentieth-century studio, Lundin utilizes his traditional artistic skills to convey a cool, distilled view of the world as he sees it today. Picasso once said that a picture is never finished beforehand but is only finished by the person viewing the work. Norman Lundin's art can be interpreted with a full range of emotions from a reassuring optimism to bleak pessimism. His art is a Rorschach test of our modern sensibilities.

1. *Degas by himself*. Edited by Richard Kendall. New York Graphic Society, 1987. Quote of Georges Jeanniot, page 299.

2. *The Prints of Edvard Munch: Mirror of His Life* by Sarah G. Epstein. Oberlin, Allen Memorial Art Museum, 1983. Page 40.

3. *From Life: Richard Diebenkorn and Norman Lundin*. Pullman, Washington State University Museum of Art, 1973.

4. *Andrew Wyeth: An Interview* by Richard Meryman. First published in *Life*, May 14, 1965. Pages 93–116, 121 as quoted on page 69 in *The Art of Andrew Wyeth* by Wanda Corn. The Fine Arts Museums of San Francisco, 1973.

AN INTERVIEW WITH THE ARTIST

PATRICIA FAILING

Patricia Failing: For the past decade you've been involved with the idea of saying more with less. What's so attractive about reductivism?

Norman Lundin: I suppose I'm attracted for the same reason people are attracted to haiku. The fewer the variables, the more important each element becomes. The formal environment I use is very fragile and the smallest change can alter it significantly. That appeals to me. I also like things that almost aren't there, but the fact that they are still there, is important.

PF: Can you remember making a self-conscious decision to pursue this direction?

NL: Only in retrospect. I was working on some drawings of a model (figure 7) and I thought, "I wonder if I can do this idea without the figure?" After a lot of experimenting, I found out that I could. The face or a figure is too much of a magnet for this kind of approach (figure 8). A face will draw the attention and tend to make everything else subordinate. So first I began removing the figures and then, over time, the furniture, trying to reduce the number of factors as far as I could and still keep the illusion convincing. Finally, there was nothing left but a corner of a room with light. That was far enough.

PF: So you worked your way into these corners and now you're working your way out?

NL: You might say that. But I'm still very interested in working with the void, with the relationship of spaces between marks or specifications. Covering a piece of paper with black charcoal won't give you an image of a void. You have to put something in there to explain or articulate it. At the same time, that thing can't become the point or focus.

PF: The void images are formally challenging, but don't you think viewers are even more affected by their psychological qualities?

NL: Yes, I think so. I think people like empty spaces.

PF: I thought people were supposed to be spooked by emptiness.

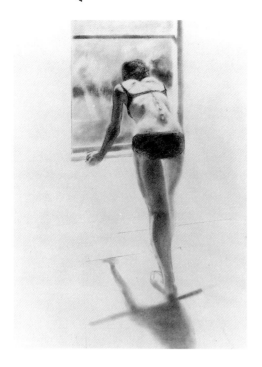

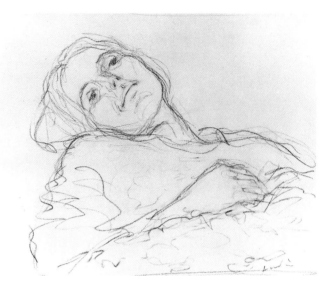

figure 7
Norman Lundin
Model at a Window, 1972
charcoal on paper, 21 × 16″
Collection of Heidi-Marie Blackwell

figure 8
Norman Lundin
Barbara, 1973
pencil on paper, 9 × 12″
Collection of Pat and Brad Scott

NL: I think people like enclosed emptiness. There are walls in my pictures— the limits of the void are finite and graspable. It's not like an astronaut's view of space, which is overwhelming. My work is not about extremes, either formally or emotionally.

PF: Now that you've brought up the topic of emotional content, I'm reminded of one of your most characteristic statements, "When formal issues are resolved, the content takes care of itself." It can't really be as simple as that—changes in form don't automatically generate changes in content. The changes come about because of the particular way you work out the form/content dialectic.

NL: Like all sweeping statements, this one has its limitations. The point is that you can only get expression through form. You can't have life without chemistry, but you can have chemistry without life. In the same way you can have form without expression, but you can't have expression without form. I'm a form-first person. Content comes second, no matter what kind of subject I'm working with. But this happened later in life. Earlier my first thoughts were always about expression and rather extreme subject matter (figure 9)—then I tried to work out the form. It's very hard to do it

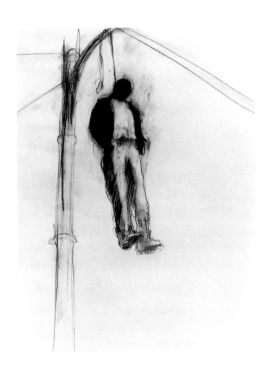

figure 9
Norman Lundin
Study for a "Brief Biography of the Cadez Family—
Hanged Man," 1967
graphite and wash on paper, 24 × 18″
Location unknown

that way; it's like fishing without a line. I finally learned that reversing the method is better. It all has to do with eloquence. Someone might say, for example, "life's short." Well, we all know that. Then you run across someone who says the same thing beautifully, like the poet who said, "The bird of life has but a short flight and, lo, it's flying now." That's what a change in form can do—make you aware of the same content, but in a more eloquent way, and when something is said eloquently, people pay attention.

PF: "Expression" is a very broad term. Just what does that word mean to you?

NL: It means the subjective aspect of the work, the psychological presence that goes beyond description of subject matter. It's a presence that's evoked by physical objects but is never literally there. The world is filled with artists who have talent and skill, but it's not filled with good expressionists, at least not in our time.

PF: Let's name names. In your view, who are some of the twentieth century's strongest expressionist painters?

NL: Edvard Munch is a favorite example. His painting, *The Scream*, is the archetype for twentieth century expressionism. I'd like to be able to think of myself as a kind of linear extension of Munch, who was, not incidentally, a considerable formalist. So is Francis Bacon, whose work I admire very much. I like Alberto Giacometti too, whose approach to content as well as composition has influenced me. I think he and Bacon are among the most significant artists of the twentieth century.

PF: It sometimes seems as though you are engaged in an art-historical game of tag with the expressionist tradition, going after the emotional import of expressionism with what seems to be an antithetical approach to form.

NL: What you can learn from history, I think, is how expression gets past form. This is the key issue. Some expressionists batter themselves against form; they exhaust themselves, pushing against it. It's like banging your fist against the wall. Maybe you can get through the wall, but your fist is a mess. So these painters tend to burn out in a big flame. Then there's someone like Francis Bacon, who is such a strong formalist. He's been working at a fever pitch for forty years. There's a lesson here.

PF: Of course it's not just the formal logic and lucidity of your work that clashes with the expressionist stereotype. It's also your subject matter. Most of the time it's almost perversely neutral.

NL: I purposely use things that are fairly common to people of my society and generation— objects that are generally as devoid of emotional luggage as possible. That's because when I used strongly loaded subject matter the emotions associated with the image did too much of the work. I don't want subject matter to "carry" the work, so I avoid extremes. I'm interested in using images that will evoke a certain range of emotions—melancholy, nostalgia, regret, maybe—as opposed to the grand passions. There's an autobiographical aspect involved too. I've worked in a lot of buildings built in the 1920s, '30s and '40s, and so I use these kinds of interior settings. Even though I don't paint from direct observation, I do have the kind of bottles and tables and drapes that show up in my work around in my studio.

PF: It's interesting to compare your subject matter with surrealist presentations of ordinary objects. In a composition by Magritte, let's say, familiar forms become disturbing, even menacing. Your ordinary-object compositions don't have that element of threat.

NL: What I'm after is content that's just slightly off-center—not something you would call odd or weird, but maybe mildly eccentric or oblique. What I do is not unrelated to Surrealism, but I'm not interested in the bizarre.

PF: One thing that seems to strike people as slightly odd about your pictures is the juxtaposition of semi-industrial or institutional-looking architecture with domestic accoutrements, like tablecloths.

NL: I think most artists would immediately recognize this as a typical studio environment, but not everyone does.

PF: The artist's studio as subject matter hasn't been seen very much in twentieth-century art since Picasso's studio scenes of the 1930s. I think these older images still serve as models for many viewers.

NL: What I want to get across in my paintings is that these are possibly real environments. I want them to look like places you could be in or might have been in. That's more important than identifying the image specifically as an artist's studio, although seeing it as a studio is okay too.

PF: Another aspect of your work that other artists might relate to in a way that non-artists wouldn't is the formal challenge of spareness, as in single-object compositions.

NL: It's like the cliche of the circus acrobat. We all know there's a lot of work involved, but it looks so easy—except to other acrobats. When I'm teaching I often ask a beginning drawing class, "What do you think would be difficult to draw?" They usually name something very complicated or intricate that would require a lot of time and tedium. Then I say, "Well, how about drawing a styrofoam cup—nothing else—on a white sheet of paper?" The technical requirements aren't great, but the conceptual requirements are very high indeed.

PF: If single-object formats are a kind of artist's art, the same might be said for your compositions that have pictures within pictures.

NL: I've shifted the focus in these compositions in the last couple of years. Before 1987, the drawing in the drawing or the painting in the painting was subordinate to the total composition. In the more recent pieces, like those with the drawing of the goat skeleton, the drawing within the drawing has become a center of attention.

PF: Where did the goat come from?

NL: I have a book on animal anatomy and I've made drawings of several skeletons. The goat skeleton was the only one that worked, however, not for any symbolic reasons, but because it's just a little offbeat. It's not too odd, but it gives a shift in cadence that's not predictable. It's also ambiguous because it's an image within an image, although you can find explanations for this ambiguity within the picture. It's purposeful ambiguity.

PF: The goat image is unusual in your work too because it's more specific than other objects. Everything else is almost completely generic—even the labels on the bottles are blank.

NL: Most of the jars and bottles you see in my pictures are transparent, but when they do have labels, it's for a specific reason, and it's not to identify the contents. As soon as you put a label on a clear jar, it has a front and a back. If it didn't have a label, it would only have volume and an up and a down and, as such, it would have a different compositional function. If a bottle has a label on it, it has a front and a back and therefore will face in a certain direction. Visually, the front will occupy more space than the back. Whether or not there are labels sounds like an insignificant point, but it's extremely important to the whole composition.

PF: Adding the dimensions of front and back to up and down obviously adds to the formal complexity, but what does it do to the psychology of the picture—to the expression?

NL: Most of my compositions are very frontal. The viewer's angle of vision is usually at right angles to the wall. Adding the label can make the object more confrontational, if it's possible to say that about a jam jar.

PF: We say that an artist like Zurbarán can confront us with an orange, so there seems to be no reason why a jam jar can't be confrontational. Viewers of your work are often confronted with an illuminated void too, as in some of the paintings of Edward Hopper. What kind of relationship do you see between your work and Hopper's? The palette is very different in each case, but there seems to be a similar feeling for structure, and perhaps even for melancholy.

NL: The formal aspects of Hopper's paintings interest me enormously, but there's a very different sensibility involved. I think he was really interested in capturing certain aspects of American life. I don't have that kind of sociological interest. Also, for me, the people in some of Hopper's paintings

are intrusions—*Sunlight in a Cafe*, for example, would be a better painting if the people weren't there. Paintings with figures like *A Woman in the Sun* or *Night Hawks* are exquisite, however. I admire Hopper, but I never felt as much at home with any American painter as I did with linavians like Munch or HammersHøi. You mentioned the difference between Hopper's palette ine. Before I went to Norway I'd seen all those bright red and blue Scandinavian ski sweaters. I got there I found that the Scandinavians don't wear them. They export those sweaters and ie black and grey ones. I really liked that, just as I felt an immediate affinity with the way ; like HammersHøi handled northern light. Even though I was young and impressionable, I at I wanted to evoke that kind of response with my pictures.

ere's a big difference, though, between the comfortably bourgeois interiors you find in nineteenth-century Scandinavian paintings and the spareness of your studio scenes.

partly because my scenes are classless, the interiors are more neutral. And because they ral, I can focus more attention on the way light hits objects as opposed to their specific qualities.

e that the architecture in your compositions tends to be as generic as the bottles and , isn't it important that you often include windows and doors, which allude to tween the inside and outside, the known and the unknown, and so on? These orms raise the possibility of change or uncertainty, which helps to set a psychological

ie doors and windows are there for straightforward formal reasons. The doors are e space on or near the picture plane and to keep the relationship between the viewer ind of equilibrium. I wouldn't deny, though, that the architecture and its scale are experience of intimacy I'd like people to have. If I were to make a broad statement psychological reaction I'm after, I'd say that I wanted to evoke quite specifically it the importance of reflection and contemplation. I talk a lot about form, but nost important factor—the very best form will never compensate for lack of ically an expressionist.

· 21 ·

PLATES AND CHECKLIST OF THE EXHIBITION

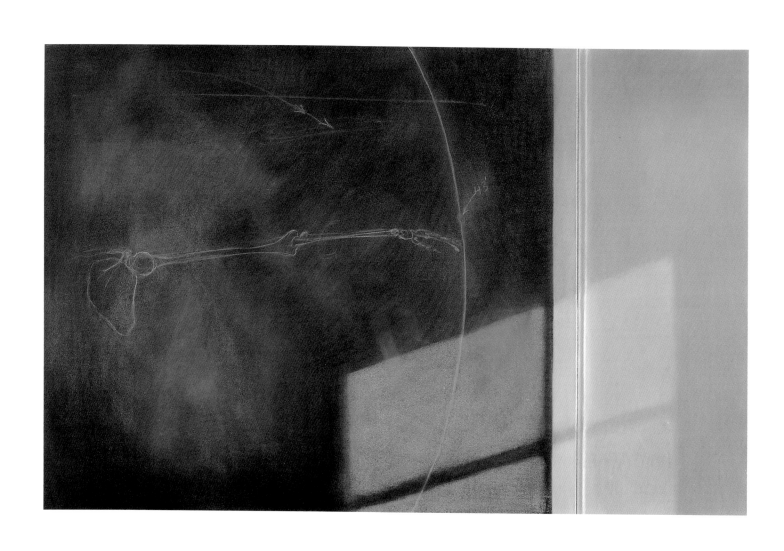

I

SAN ANTONIO ANATOMY LESSON, 1981–82
pastel on paper, 28 × 44″
Collection of Cliff Michel, Seattle

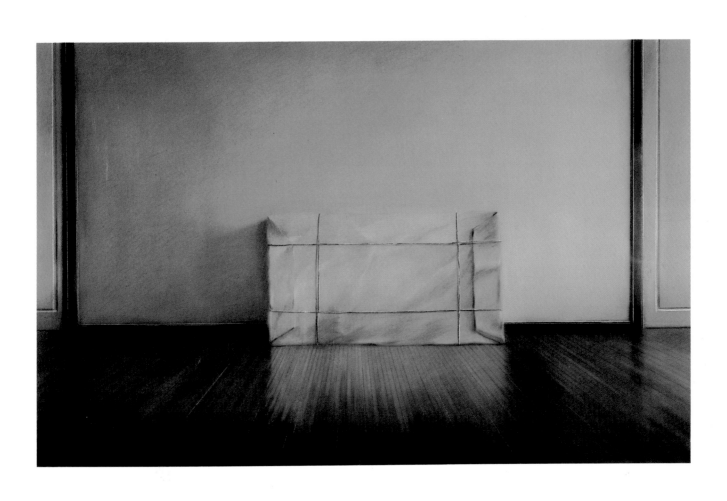

2
60TH STREET STUDIO: WRAPPED PACKAGE, 1983
pastel on paper, 27 × 43″
Riddell, Williams, Bullitt & Walkinshaw, Seattle

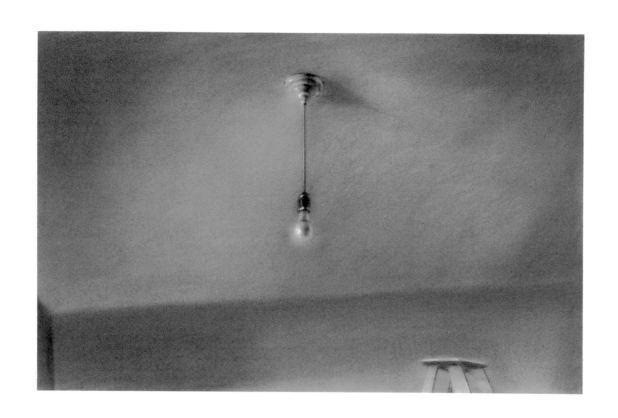

3
STUDIO CEILING, 1986
pastel on paper, 14 × 22″
Charles Rynd, Seattle

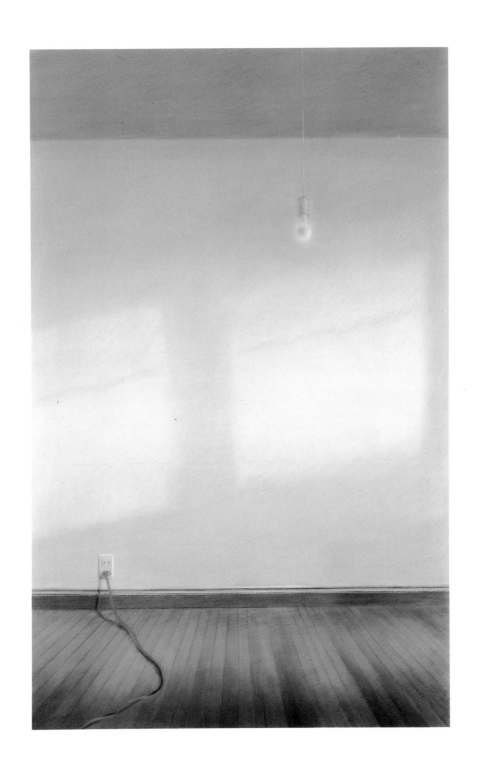

4
RED ELECTRICAL CORD & LIGHTBULB #2, 1989
pastel on paper, 44 × 28″
Courtesy of Olga Dollar Gallery, San Francisco

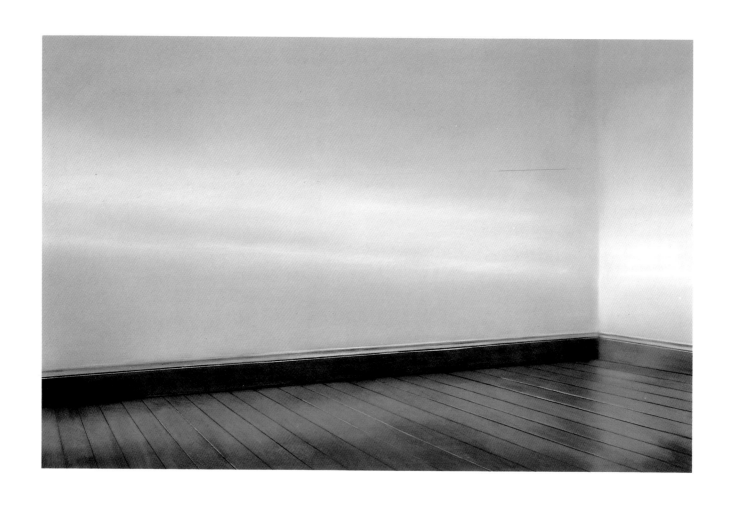

5
LIGHT OBSERVATIONS: EARLY MORNING, 1986
pastel on paper, 28 × 44″
Courtesy of Space Gallery, Los Angeles

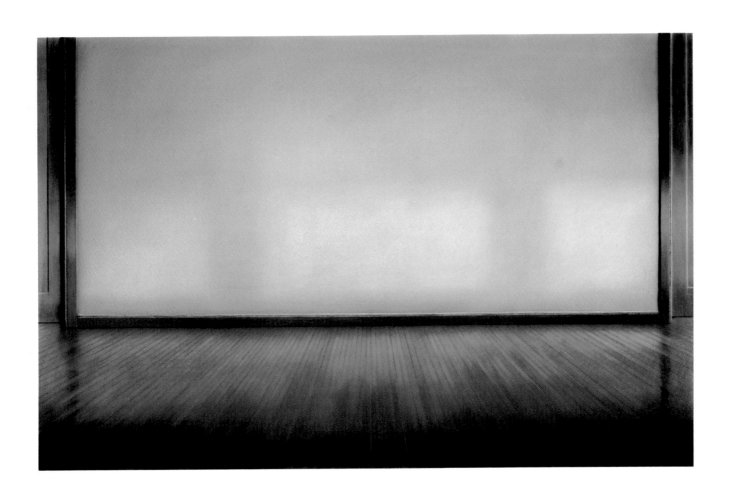

6
60TH STREET STUDIO: ABOUT 8:00 A.M., 1986
pastel on paper, 28 × 44″
Private Collection

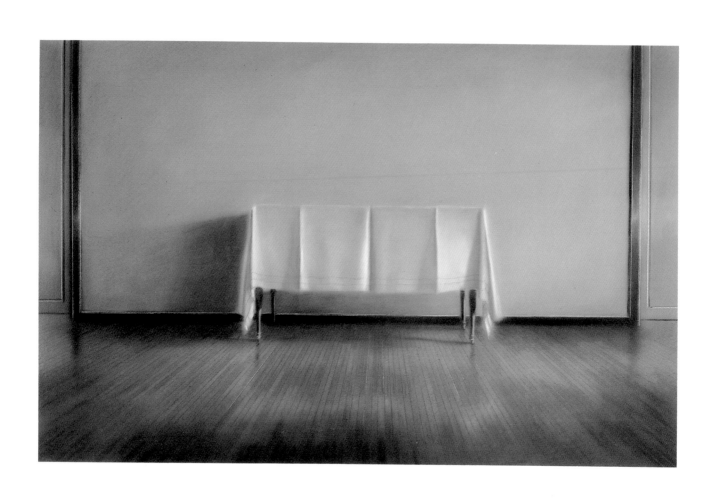

7
6 0 T H S T R E E T S T U D I O : W H I T E T A B L E C L O T H , 1 9 8 3
pastel on paper, 28 × 44″
Seattle City Light Portable Works Collection

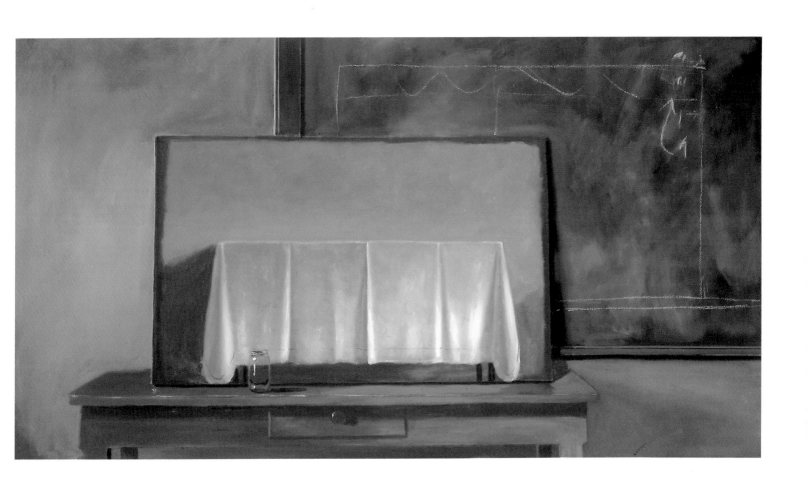

8

STUDIO: BOTTLE & STUDY OF WHITE TABLECLOTH, 1989
oil on canvas, 36 × 66″
Courtesy of Stephen Haller Fine Art, New York

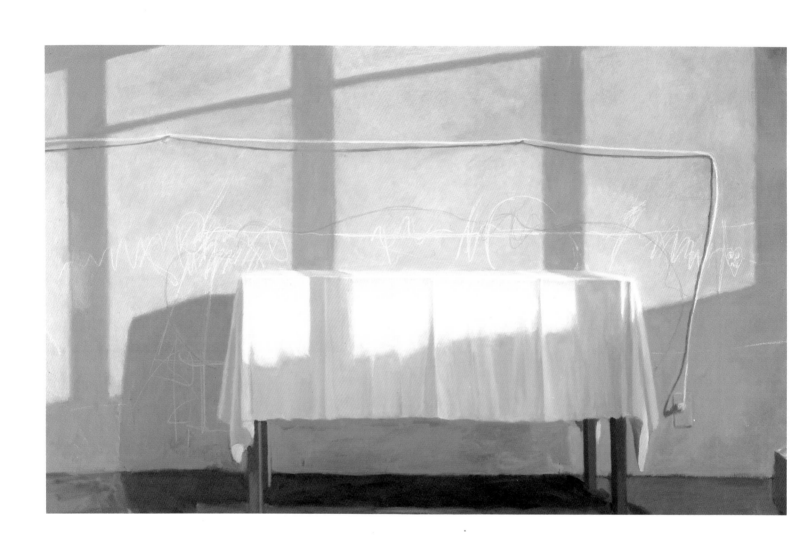

9
STUDIO: STILL LIFE TABLE & GRAFFITI, 1987
oil on canvas, 40 × 66″
Rundy Bradley, Houston

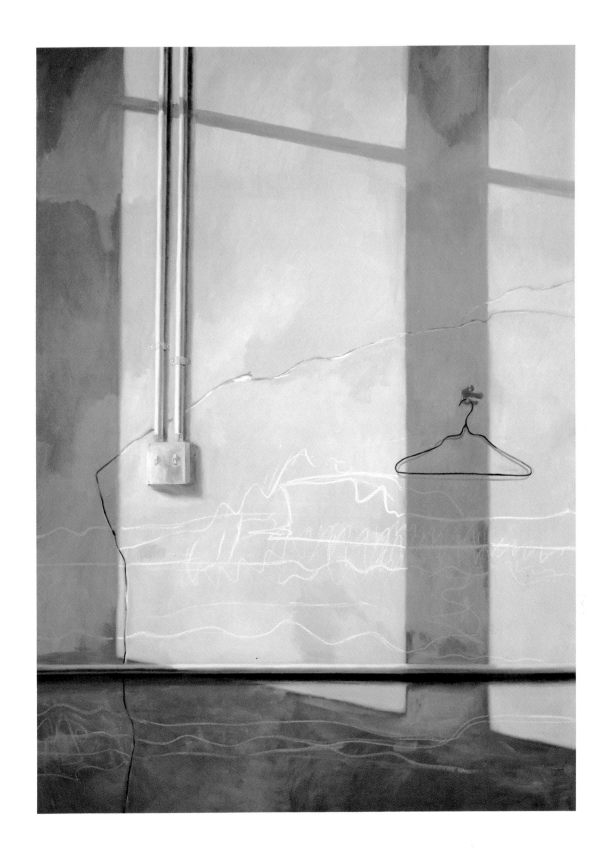

10
STUDIO WALL & COAT HANGER, 1987
oil on canvas, 70 × 50″
From the collection of Mike and Janet Slosberg

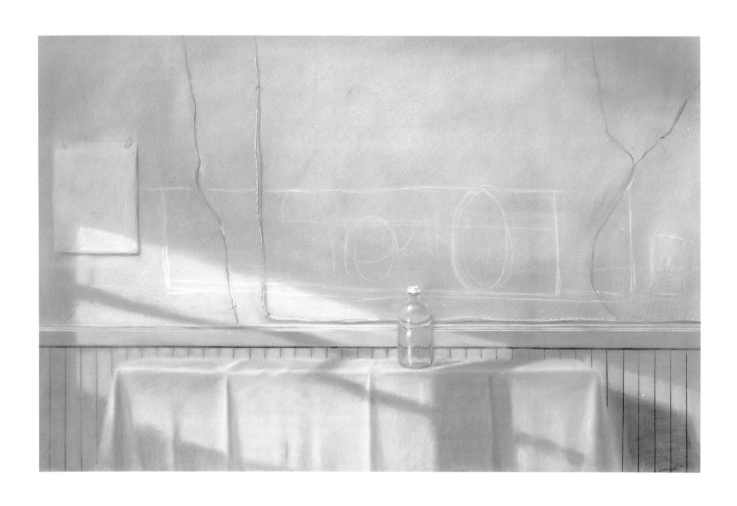

11

STUDIO STILL LIFE: YELLOW TABLECLOTH & JAR, 1989
pastel on paper, 44 × 28″
Courtesy of Stephen Haller Fine Art, New York

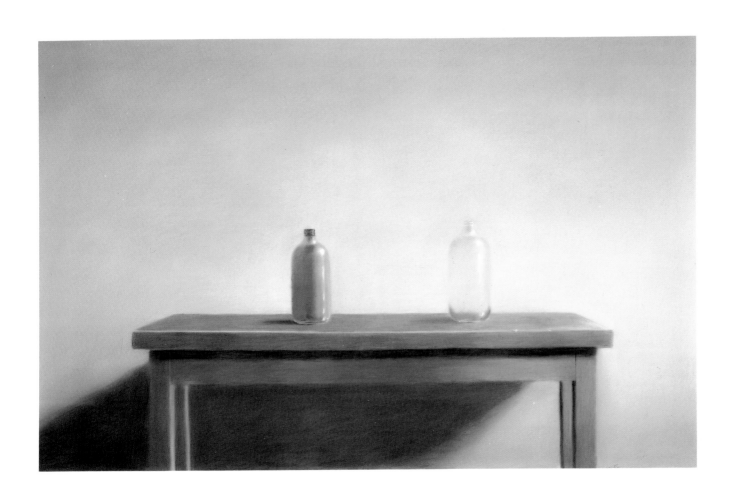

12

SIMPLE STILL LIFE: TWO BOTTLES, 1986

pastel on paper, 28 × 44″

Sidney and George Perutz

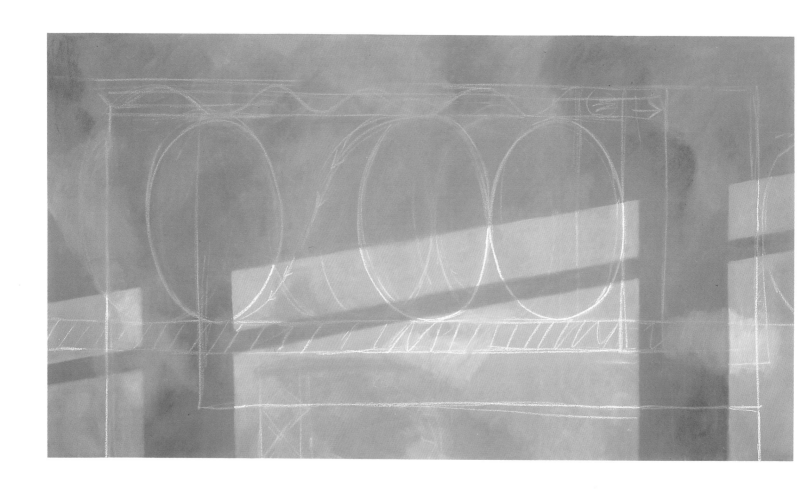

13
BIG BLACKBOARD, 1988
oil on canvas, 46×84″
Courtesy of Stephen Haller Fine Art, New York

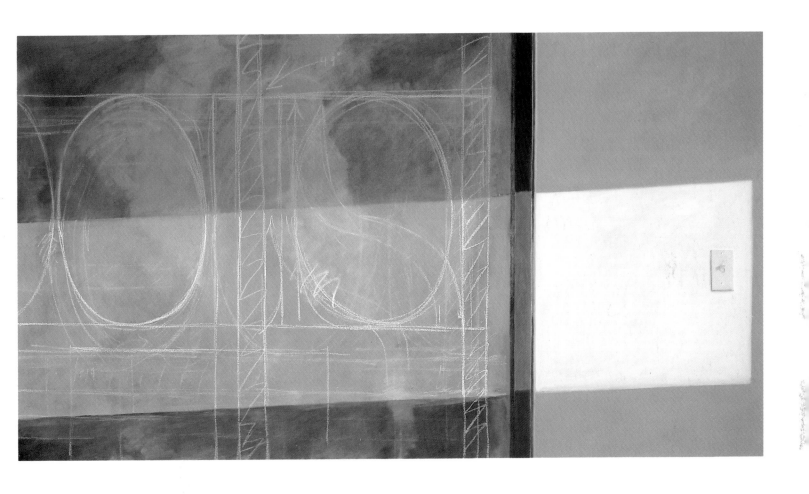

14
STUDIO WALL & BLACKBOARD, 1988
oil on canvas, 48 × 84″
Courtesy of Olga Dollar Gallery, San Francisco

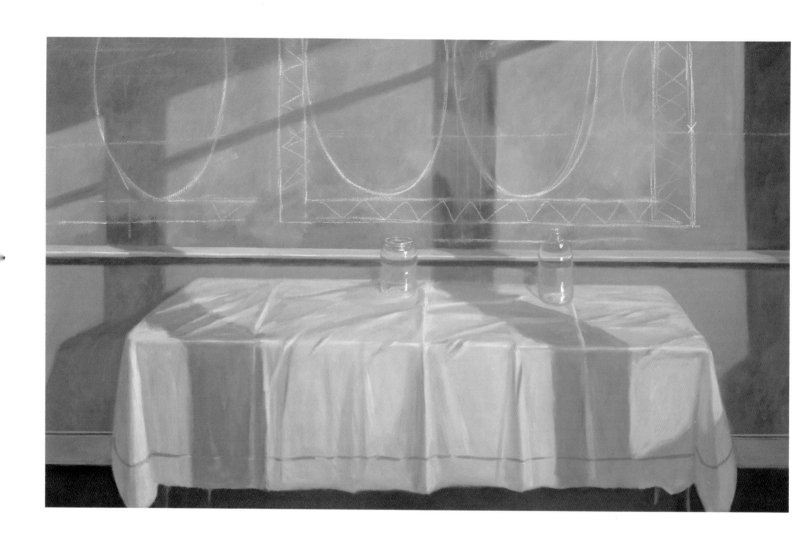

15

BLUE TABLECLOTH, TWO JARS & A BLACKBOARD, 1987
oil on canvas, 40 × 66″
Collection of Jane M. and David R. Davis, Medina, Washington

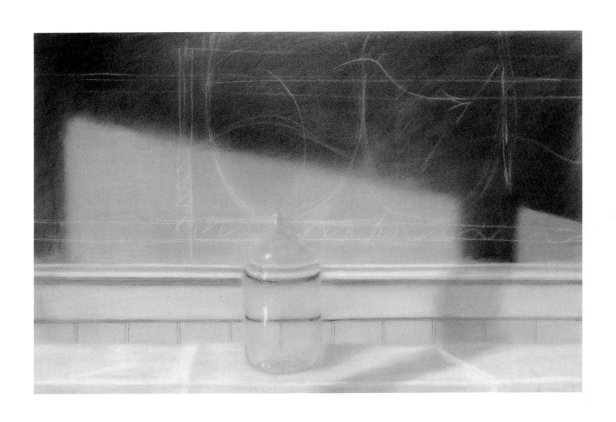

16
TABLE, BOTTLE & CHALKBOARD, 1987
pastel on paper, 14 × 22″
Jil and Mark Kreher

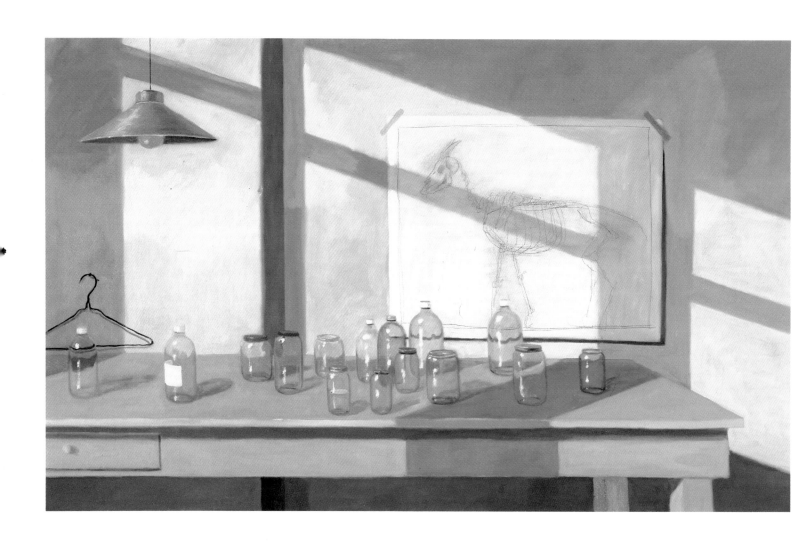

17
STUDIO: 15 JARS & A DRAWING, 1987
oil on canvas, 40 × 66″
Courtesy of Adams-Middleton Gallery, Dallas

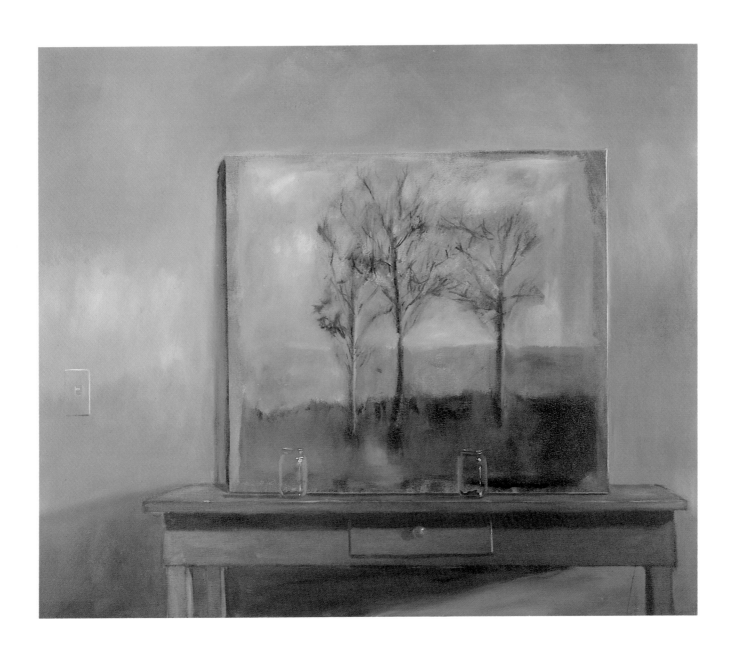

18
STUDIO STILL LIFE: TWO JARS & A LANDSCAPE, 1989
oil on canvas, 40×48″
Courtesy of the Artist and Francine Seders Gallery, Seattle

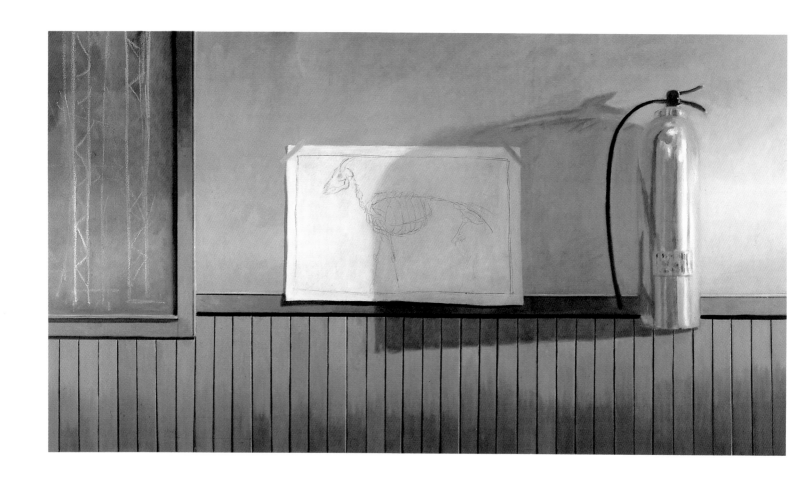

19
STUDIO STILL LIFE: FIRE EXTINGUISHER & DRAWING OF A GOAT, 1987–88
oil on canvas, 36 × 66″
Courtesy of the Artist and Francine Seders Gallery, Seattle

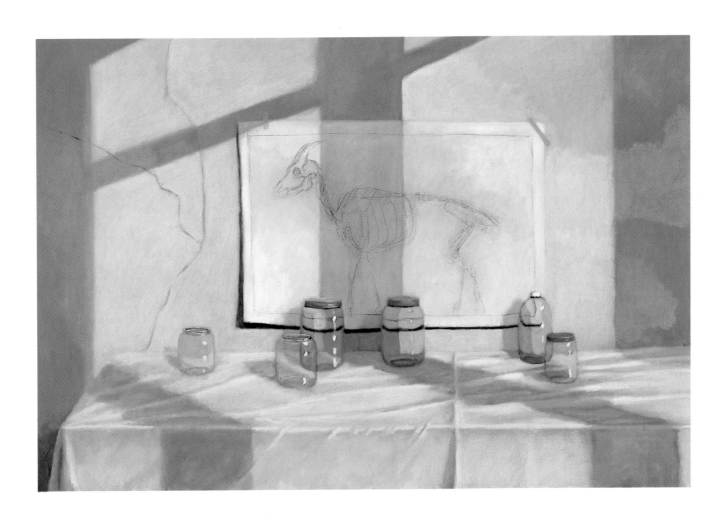

20

SIX JARS, TABLE AND DRAWING, 1986
oil on canvas, 36 × 54″
Collection of the Goldberg Foundation

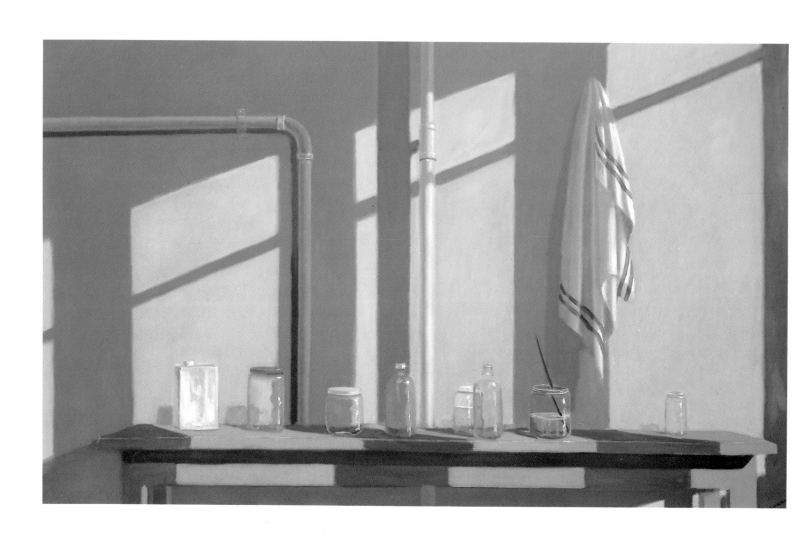

21
STUDIO TABLE: MANY JARS & BOTTLES, 1989
oil on canvas, 36×66″
Courtesy of Stephen Haller Fine Art, New York

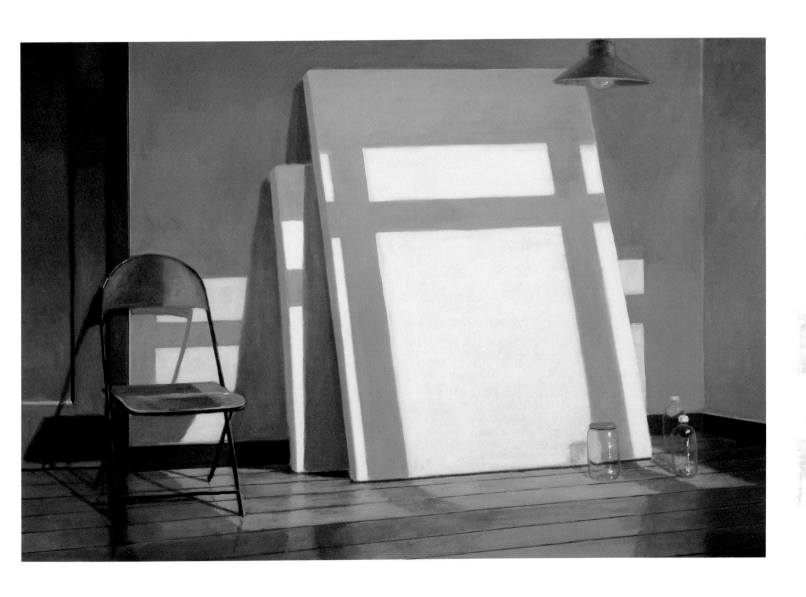

22
STUDIO INTERIOR: BLANK CANVASES & A CHAIR, 1989
oil on canvas, 44 × 66"
Private Collection

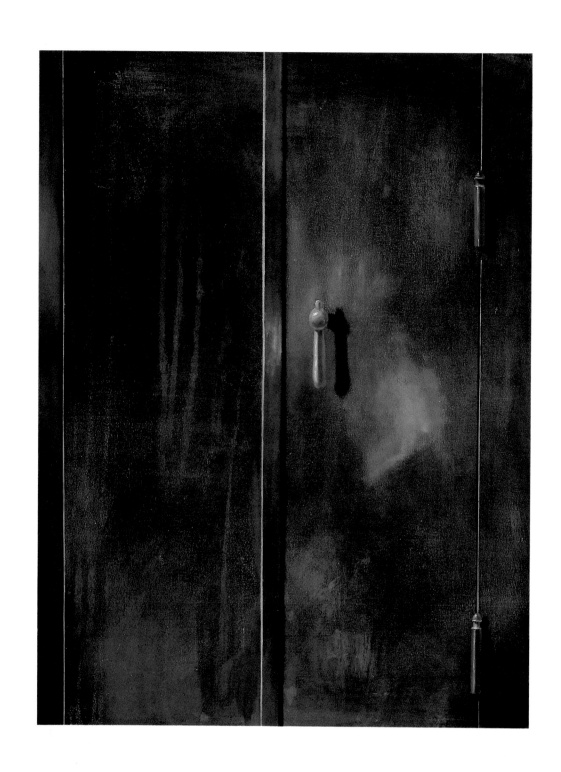

23
METAL DOOR #2, 1988
oil on canvas, 48 × 36″
Courtesy of the Artist

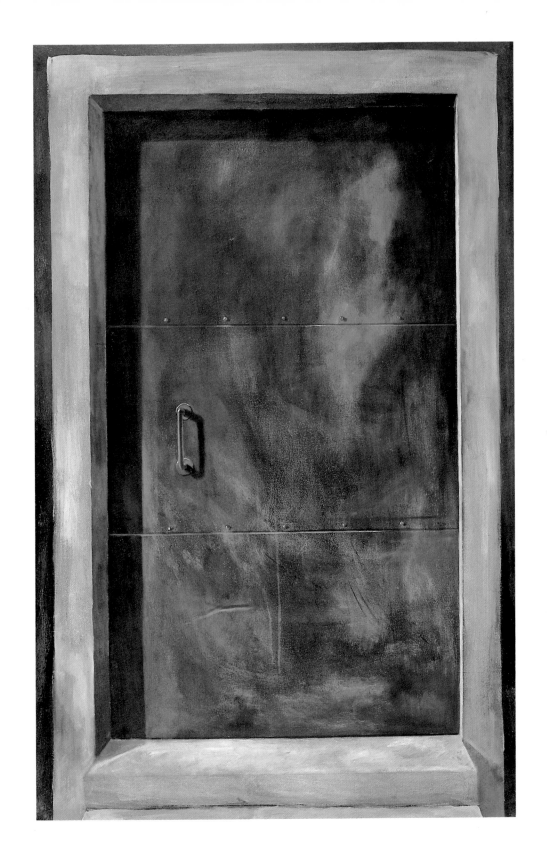

24
FACTORY BUILDING: FIRE DOOR, 1988
oil on canvas, 66 × 42″
Courtesy of the Artist and Francine Seders Gallery, Seattle

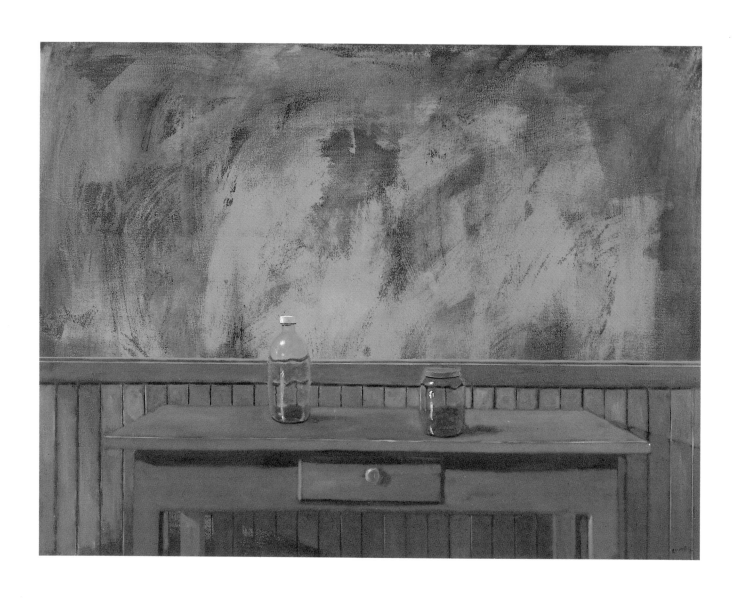

25
STUDIO: BOTTLE & JAR WITH RED CAP, 1989
oil on canvas, 36 × 48″
Courtesy of Space Gallery, Los Angeles

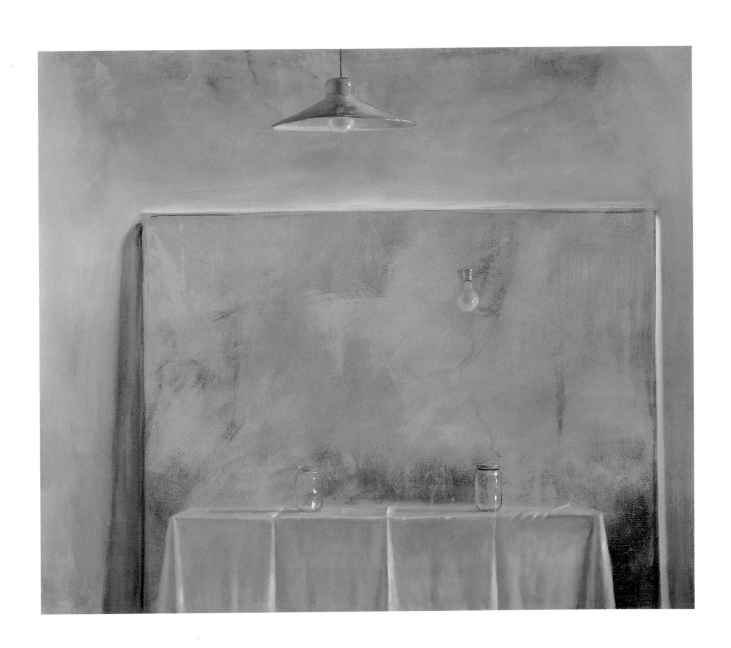

26

STUDIO INTERIOR: LAMP, LIGHTBULB & TWO JARS, 1989
oil on canvas, 40 × 48″
Courtesy of the Artist and Francine Seders Gallery, Seattle

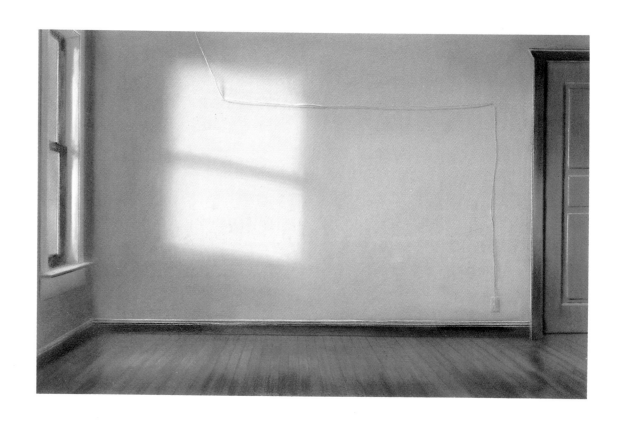

27
ROOM WITH AN ELECTRICAL CORD, 1986
pastel on paper, 14 × 22″
Courtesy of Ardys and Robert Allport, Tiburon, California

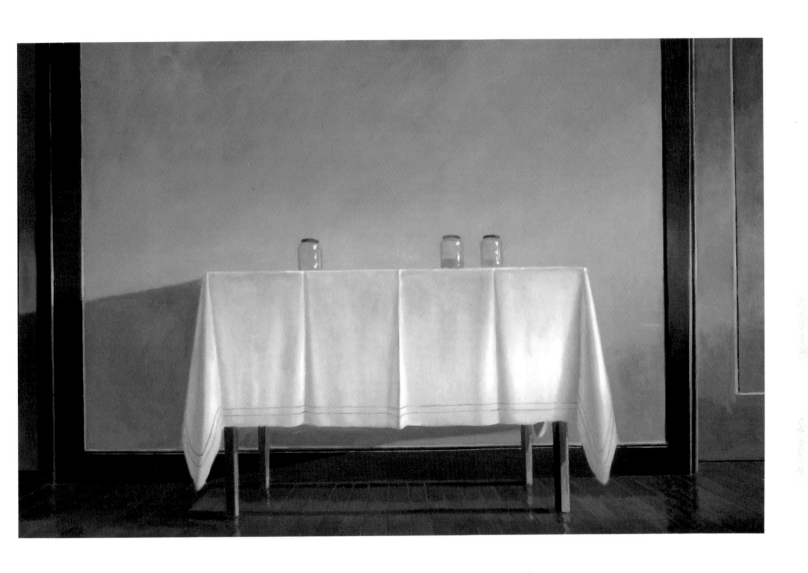

28
STUDIO STILL LIFE: THREE JARS, 1989
oil on canvas, 42 × 66″
Collection of Carlin Axelrod, New York

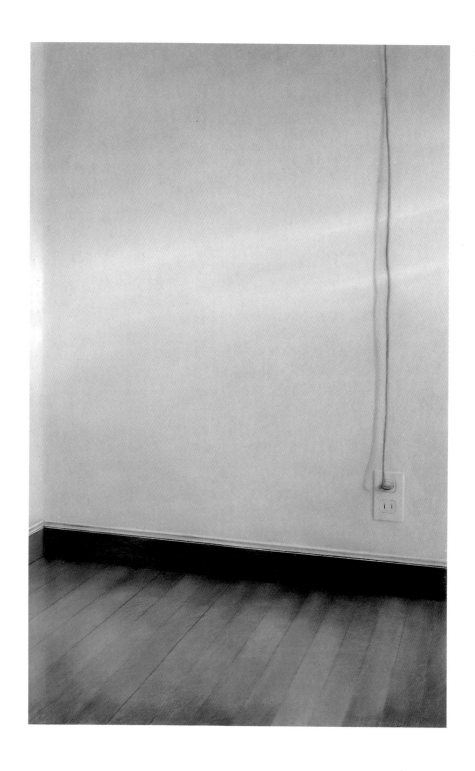

29
LIGHT OBSERVATIONS: WALL & RED ELECTRICAL CORD, 1986
pastel on paper, 44 × 28″
Gary and Kathleen Schneiderman

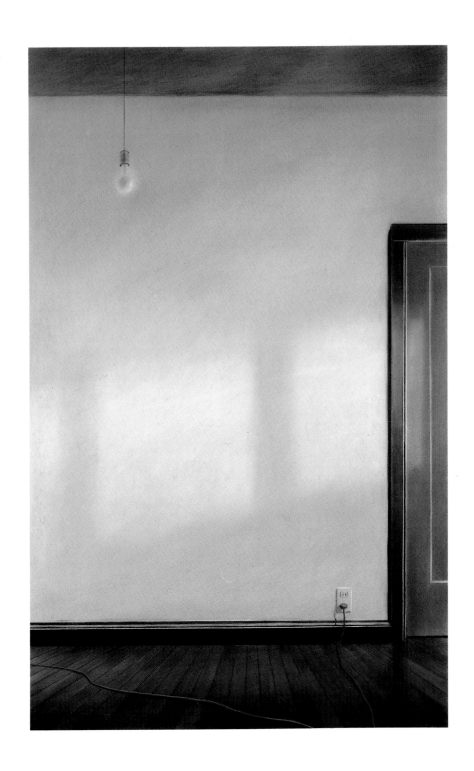

30
RED ELECTRICAL CORD & LIGHTBULB #1, 1989
pastel on paper, 44 × 28″
Courtesy of Olga Dollar Gallery, San Francisco

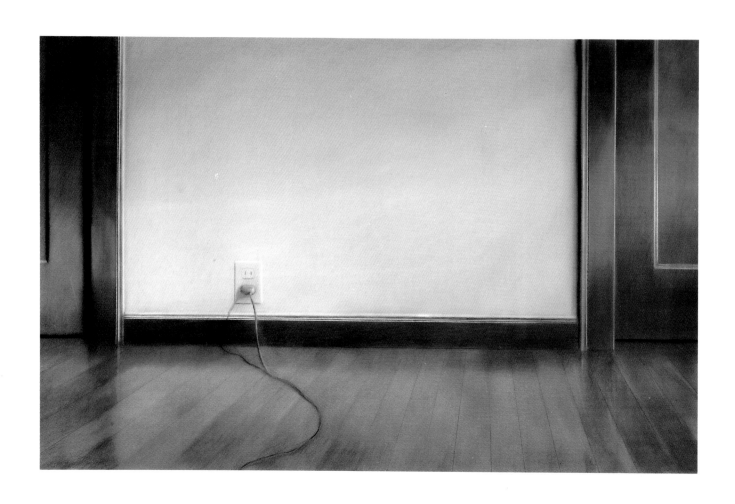

31

TWO DOORS, EXTENSION CORD & FLOOR, 1988
pastel on paper, 28 × 44″
Courtesy of Adams-Middleton Gallery, Dallas

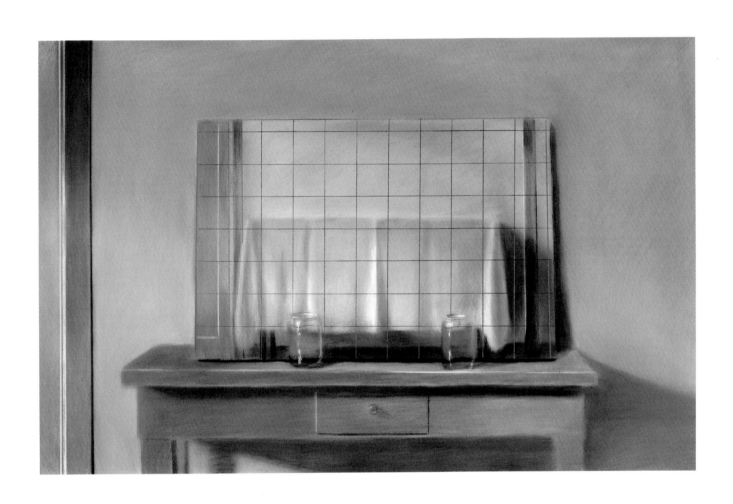

32
TWO JARS & STUDY OF WHITE TABLECLOTH, 1989
pastel on paper, 28 × 44″
Courtesy of Adams-Middleton Gallery, Dallas

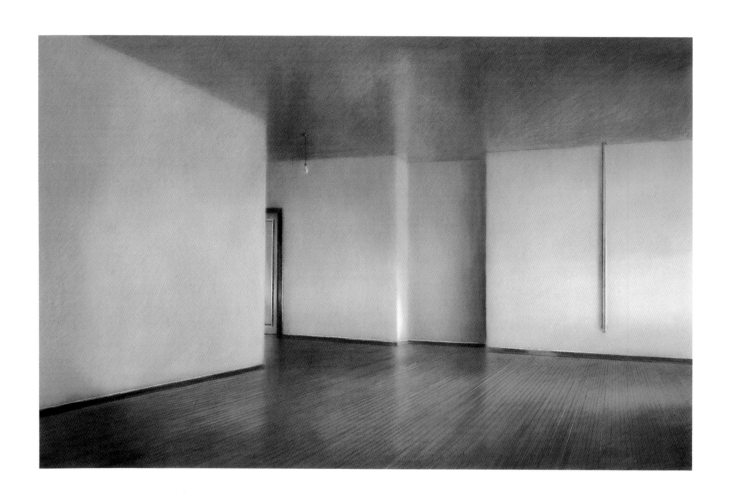

33
STUDIO CORRIDOR #14, 1983
pastel on paper, 28 × 44″
The Fine Arts Museums of San Francisco
Achenbach Foundation for Graphic Arts, George F. Poole Jr. Fund

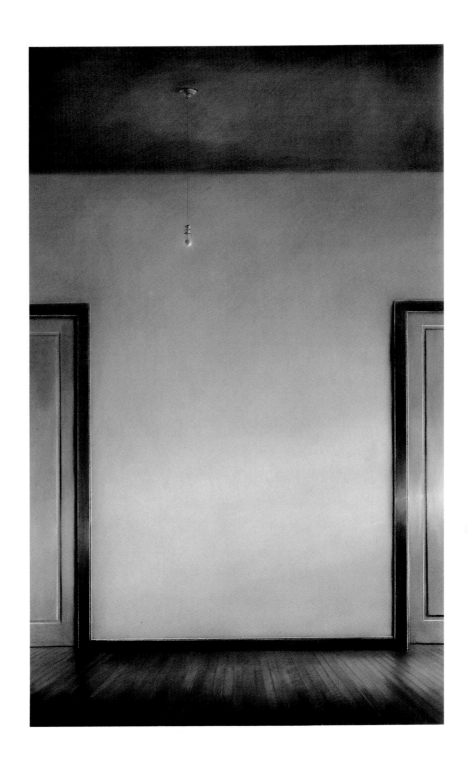

34
60TH STREET STUDIO: CORRIDOR, 1985
pastel on paper, 44 × 28″
Huntsville Museum of Art, Huntsville, Alabama
Huntsville Museum Association Purchase, 1987

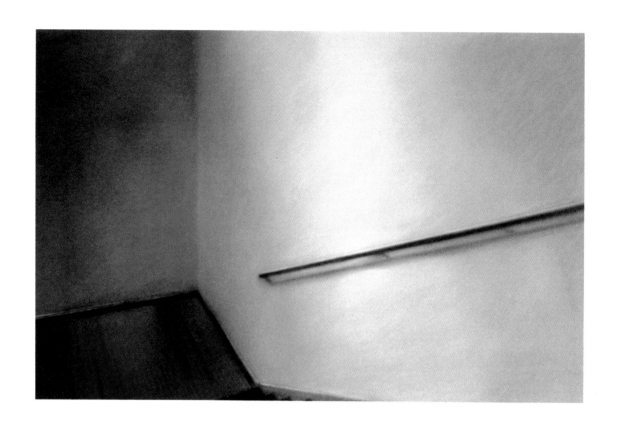

35
60TH STREET STUDIO: STAIRWELL, 1984
pastel on paper, 14 × 22″
Collection Patricia and Andrew Bauman

NORMAN K. LUNDIN

Born: Los Angeles, December 1, 1938

1988
Allport/Caldwell Gallery, San Francisco
Port Angeles Fine Art Center, Port Angeles,
Washington

1987
Stephen Haller Fine Art, New York
Whitworth College, Spokane, Washington
Cabrillo College, Aptos, California
Adams-Middleton Gallery, Dallas

1986
Francine Seders Gallery, Seattle
Space Gallery, Los Angeles

1985
Allport Gallery, San Francisco
Yellowstone Art Center, Billings, Montana
Adams-Middleton Gallery, Dallas

1984
Allport Gallery, San Francisco
Seattle Art Museum, Seattle
Space Gallery, Los Angeles

1983
San Jose Museum of Art, San Jose, California
Saddleback College, Mission Viejo, California

1982
University of Texas at San Antonio
Space Gallery, Los Angeles

1981
Jack Rasmussen Gallery, Washington, DC
Francine Seders Gallery, Seattle

1980
Space Gallery, Los Angeles
University of North Dakota, Grand Forks

1979
Western Washington State University, Bellingham,
Washington

1978
Allan Stone Gallery, New York
Space Gallery, Los Angeles

1976
Francine Seders Gallery, Seattle

1975
Ohio State University, Columbus
Rockford College, Rockford, Illinois
Oregon State University, Corvallis, Oregon
Viterbo College, La Crosse, Wisconsin

1974
Tacoma Art Museum, Tacoma, Washington

1973
Western Washington State University, Bellingham,
Washington

1969
Otto Seligman/Francine Seders Gallery, Seattle

1968
Fountain Gallery, Portland, Oregon

1967
Otto Seligman/Francine Seders Gallery, Seattle

1966
Atrium Gallery, Seattle

1964
Diedrich Anderson Gallery, Bergen, Norway

1963
American Embassy, Oslo
Gilman Galleries, Chicago

SELECTED GROUP SHOWS

1990
"National Invitational Exhibition of Painting and
Sculpture," American Academy and Institute of Arts
and Letters, New York

1989
"Annual Purchase Exhibition," American Academy
and Institute of Arts and Letters, New York
"National Invitational Drawing Exhibit," Emporia
State University, Emporia, Kansas

1988
"Contemporary Landscapes," (Curated by Museum
of Modern Art, New York) The Vault Gallery, Boston
"Twelve Contemporary Artists," Twin Cities Art
Foundation, Dallas
"Downtown Perspectives," Adelphi University, New
York
"American Realism," Boise Art Museum, Boise, Idaho

"Across America," Francine Seders Gallery, Seattle

"Ancient Elements in the Contemporary Landscape," Pacific Bell Headquarters, San Francisco

1987
"Drawing the New Tradition," Huntsville Museum of Art, Huntsville, Alabama

"Focus: Seattle," San Jose Museum of Art, San Jose, California

"National Drawing Invitational," Arkansas Art Center, Little Rock

1986
"A Perfect Match: Northwest Impressions, Works on Paper," Henry Art Gallery, University of Washington, Seattle

"38th Annual Academy-Institute Purchase Exhibition," American Academy & Institute of Arts & Letters, New York

"Chicago Art Expo," Works featured by Adams-Middleton Gallery, Dallas

1985
"American Realism, 20th Century Drawings & Watercolors," San Francisco Museum of Modern Art, San Francisco

"Sources of Light: Contemporary Luminism," Henry Art Gallery, University of Washington, Seattle

"Landscapes," Francine Seders Gallery, Seattle

1984
"America Seen," Adams-Middleton Gallery, Dallas

1983
"West Coast Realists," organized by Laguna Beach Museum of Art, Laguna Beach, California (U.S. museum tour through 1985)

"Contemporary Seattle Art of the 1980's," Bellevue Art Museum, Bellevue, Washington

1981
"Portopia '81," Washington Artists Exhibition, Kobe, Japan

"Governor's Invitational," State Capitol Museum, Olympia, Washington

"Seattle Drawings Invitational," Seattle Pacific University, Seattle

1980–81
"Illusionism: Washington Year Exhibition," Henry Art Gallery, University of Washington, Seattle

1980
"Northwest Artists: A Review," Seattle Art Museum

"Invitational Drawing & Watercolor Exhibition," Municipal Art Gallery, Barnsdall Park, Los Angeles

"Invitational Exhibition," Santa Barbara Museum

"Annual Invitational Drawing Show," Art Center Gallery, Seattle Pacific University, Seattle

1979
"Seattle Selects," sponsored by the Seattle Arts Commission, One Percent for Art Program, Seattle

"Recent Acquisitions," Museum of Modern Art, New York

1978
"The Objects Observed," Los Angeles Municipal Museum

"Recent Acquisitions: Contemporary Art," Seattle Art Museum

1977
"Northwest '77," Seattle Art Museum

"Drawings," Miami University, Miami, Ohio

Texas Fine Arts Association, Austin

1976
"Northwest Masters," Seattle Art Museum

1975
"Invitational Show of College Art Instructors," University of Illinois, Urbana

"Rutgers National Drawing Show," Rutgers University, Camden, New Jersey

"Davidson National Exhibition," Davidson College, Davidson North Carolina

"Northwest Painters Invitational," Washington State University Museum of Art, Pullman

"Northwest Painters & Sculptors," Seattle Art Museum

"Art of the Figure," University of Nevada, Las Vegas

1974
"Drawings '74," Wheaton National Drawing Show, Norton, Massachusetts

"Images on Paper," Springfield Art Association, Springfield, Illinois

"New Talent," Forum Gallery, New York

1973
"From Life: Richard Diebenkorn and Norman Lundin," Washington State University Museum of Art, Pullman

"National Drawing & Print Competition," Oklahoma Art Center, Oklahoma City

1972
"Grand Galleria National Competition," Seattle
"Prospect Northwest," Seattle Art Museum

1971
"Drawings & Prints," Les Editions de la Tortue, Paris
"Centennial Exhibition," San Francisco Art Museum
"Western Annual," Denver Art Museum
"Drawing Biennial," St. Paul Art Center, St. Paul, Minnesota

1970
"National Drawing Invitational," University of Wisconsin, Madison, Wisconsin
"Invitational Exhibition," Judith Weingarten Gallery, Amsterdam
"Invitational Exhibition," New Grafton Gallery, London,

1969–70
"Human Concern," Whitney Museum of American Art, New York and University of California at Berkeley

1969
"Northwest Annual," Seattle Art Museum
"Gallery Artists," Picadilly Gallery, London

1968
"Gallery Artists," Pro-Gradica Gallery, Chicago
"Drawings U.S.A.," St. Paul Art Center, St. Paul, Minnesota
"Bradley Print Show," Bradley University, Peoria, Illinois
"New Directions," Nordness Gallery, New York

1967
"53rd Exhibition of Northwest Artists," Seattle Art Museum

1966
"52nd Exhibition of Northwest Artists," Seattle Art Museum
"Art of Washington," University of Oregon, Eugene
"American Printmakers," Auburn University, Auburn, Alabama
"National Drawing Competition," Del Mar College, Corpus Christi, Texas

1965
"51st Exhibition of Northwest Artists," Seattle Art Museum, Seattle
"Northwest Printmakers," Cheney Cowles Museum, Spokane and University of Washington

1964
"50th Exhibition of Northwest Artists," Seattle Art Museum
"Bucknell Annual," Bucknell University, Lewisburg, Pennsylvania

1963
"American Drawings & Small Sculpture," Ball State University, Muncie, Indiana
"Artists of Cincinnati and Vicinity 18th Annual Exhibition, Cincinnati Art Museum

SELECTED BIBLIOGRAPHY

Catalogues/Books (listed chronologically)

1990
Enstice, Wayne, *Drawing/Space, Form, Expression*, Prentice/Hall

1987
Adams-Middleton Gallery, *Norman Lundin, Space + Light*, Dallas

1985
San Francisco Museum of Modern Art, *American Realism, 20th Century Drawings and Watercolors*, San Francisco
Henry Art Gallery, University of Washington, *Sources of Light: Contemporary Luminism*, Seattle

1984
Adams-Middleton Gallery, *America Seen*, Dallas

1983
Guenther, Bruce and Burns, Marsha, *50 Northwest Artists*, Chronicle Books, San Francisco
Gamwell, Lynn, *Westcoast Realism*, Laguna Beach Museum of Art, Laguna Beach, California
Seattle Art Museum and Francine Seders Gallery, *Norman Lundin: Works on Paper*, Seattle

1982
Henry Art Gallery, University of Washington, *The Washington Year, A Contemporary View: 1980–81*, Seattle

1979
Western States Arts Foundation, *The First Western States Biennial*, Denver

1977
Henry Art Gallery, *School of Art, University of Washington*, Seattle

1975
Biegler, Steve and Crane, Tim, *Norman Lundin*,
Viterbo College, La Crosse, Wisconsin

Rutgers University, *National Drawing Exhibition*,
Camden, New Jersey

Webb, Peter, *The Erotic Arts*, New York Graphic
Society, Boston

1973
Oklahoma Art Center, *15th Annual National Exhibition of Prints & Drawings*, Oklahoma City

1973
Steefel Jr., Lawrence, *Norman Lundin—From Life*,
Department of Fine Arts, Washington State University, Pullman

1971
Denver Art Museum, *73rd Western Annual*

1969
Doty, Robert, *Human Concern*, Whitney Museum of
American Art, New York

University of Oregon, *9th Northwest Art Annual*,
Eugene

1968
Merill, David, *Norman Lundin*, Fountain Gallery,
Portland, Oregon

Seattle Pacific College, *Drawing Exhibition*, Seattle

St. Paul Art Center, *Drawings U.S.A.*, St. Paul,
Minnesota

Bucknell University, *The Third Annual National
Drawing Exhibition*, Bucknell, Pennsylvania

1967
Jenkins, Paul Ripley, *Norman Lundin*, Otto Seligman/Francine Seders Gallery, Seattle

1961–2
Cincinnati Art Museum, *Artists of Cincinnati and
Vicinity*, Cincinnati

PHOTOGRAPHY CREDITS

1, 2, 3, 7, 16, 18, 19, 23, 24, 26 Chris Eden, Seattle
4, 14, 27, 30 Robert Cross, San Francisco
5, 25 Susan Einstein
6, 22 Dwight Primiano, New York
8, 11, 13, 15, 21, 28 Courtesy Stephen Haller Fine Art, New York
9, 12, 17, 31, 32 Scott Metcalfe, Dallas
10 Douglas Christian, Boston
20 John C. Lutsch, Boston
29 Robert DiFranco, Sacramento
33 Courtesy The Fine Arts Museums of San Francisco
34 Roy Simmons, Huntsville

LIBRARY OF CONGRESS CATALOGING IN PUBLICATION DATA
Lundin, Norman.
Norman Lundin: a decade of drawing and painting /
interview with the artist by Patricia Failing; introduction by Robert Flynn Johnson.
p. cm.
Includes bibliographical references.
ISBN 0-295-97049-9
1. Lundin, Norman—Exhibitions. I. Failing, Patricia. II. Long Beach
Museum of Art. III. Tai Associates International Inc. IV. title.
N6537.L85A4 1990
759.13—dc20 90-36105
 CIP